Virtue
vs.
Vice

Cecily Moon and Sandra Meigs

Virtue
vs.
Vice

Walter Phillips Gallery

Walter Phillips Gallery
The Banff Centre for the Arts
Box 1020–14
Banff, Alberta
Canada T0L 0C0
(403) 762-6281

Canadian Cataloguing in Publication Data

 Virtue vs. vice / Cecily Moon, Sandra Meigs

ISBN 0-920159-43-5

1. Moon, Cecily. 2. Meigs, Sandra.
3. Virtues in art. 4. Vices in art.
5. Artists' books—Canada.
I. Meigs, Sandra. II. Walter Phillips Gallery. III. Title.
N7433.4.M65A75 1993 709'71 C93-091171-7

**The Banff Centre
for the Arts**

In this collaborative book project, artists Cecily Moon and Sandra Meigs explore emotional ideas behind moral struggles. Influenced by the battle in the *Hortus Delicarium*, a twelfth-century moral tract by Herrad of Landsberg, the artists have pitted the seven virtues against the seven vices, creating images that refer to centuries of tradition. Drawing on the history of these concepts personified, the artists show how traditional themes are still operating in subtle ways.

The images in this book have been created through a process that originally began as a game of snakes and ladders. Each artist started by drawing fourteen characters, which were arranged in the order they now appear. The collaboration began when they took turns drawing them in combat, transforming the parts into a continuous whole.

Cecily Moon is representing the virtues:
chastity, hope, love, prudence, temperance, justice and faith.
Sandra Meigs is representing the vices:
envy, gluttony, covetousness, sloth, anger, pride and lust.

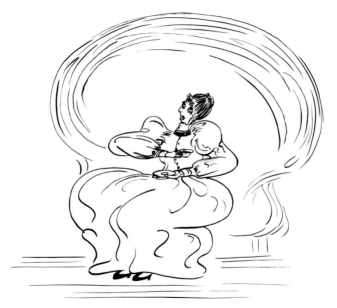

Envy

Envy meets Chastity

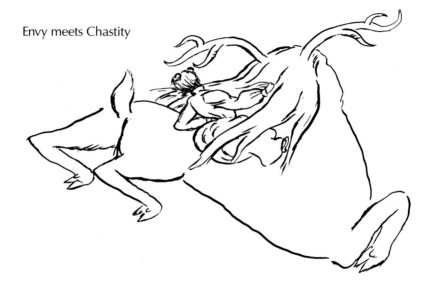

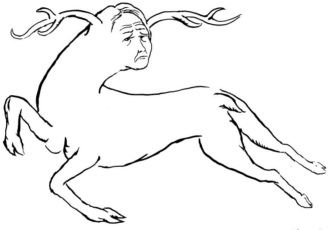

Chastity

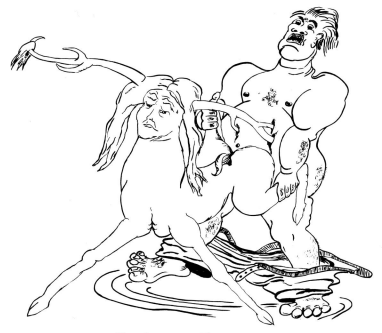

Chastity meets Gluttony

Gluttony

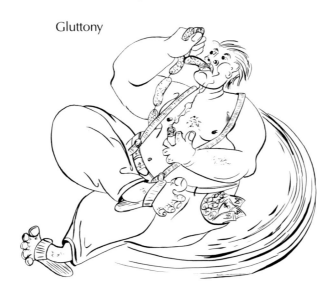

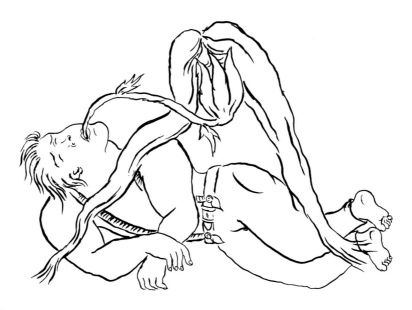

Gluttony meets Hope

Hope

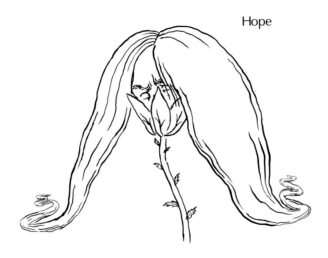

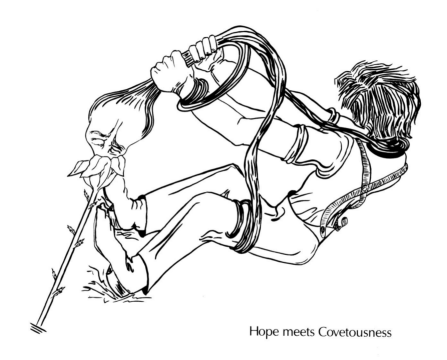

Hope meets Covetousness

Covetousness

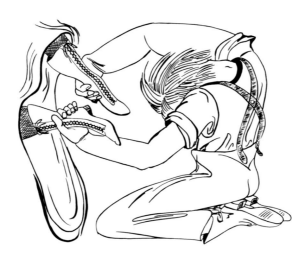

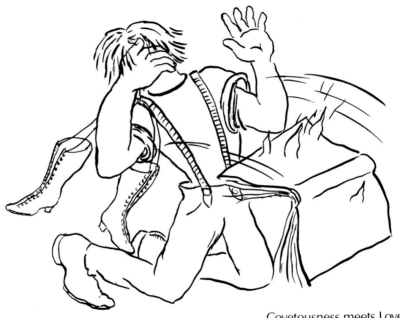

Covetousness meets Love

Love

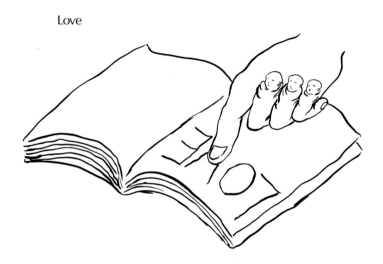

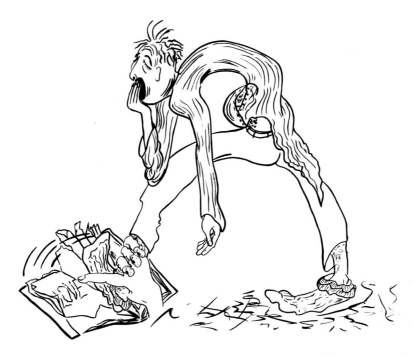

Love meets Sloth

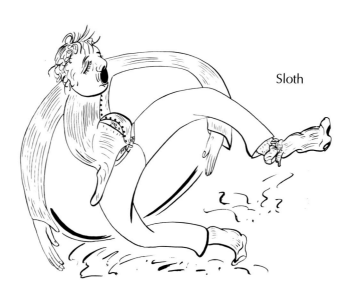

Sloth

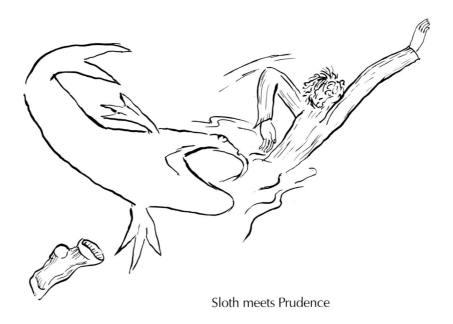

Sloth meets Prudence

Prudence

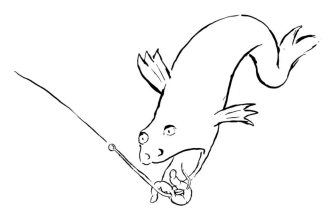

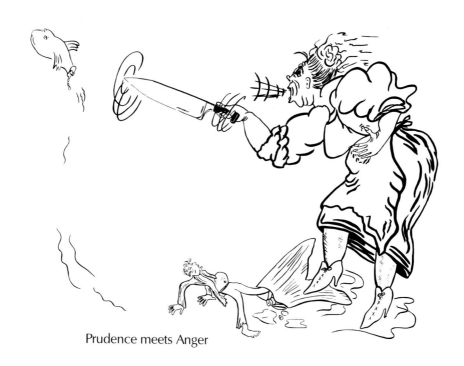

Prudence meets Anger

Anger

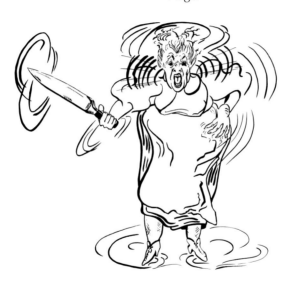

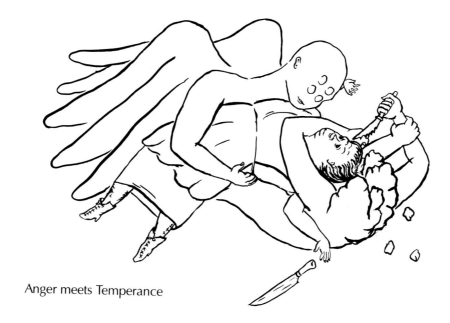

Anger meets Temperance

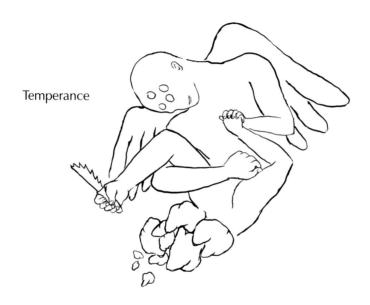

Temperance

Temperance meets Pride

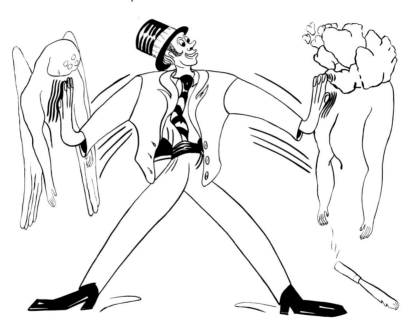

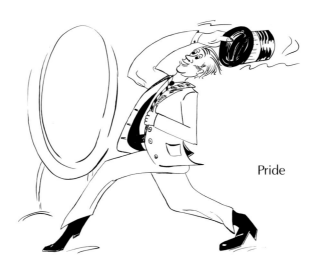

Pride

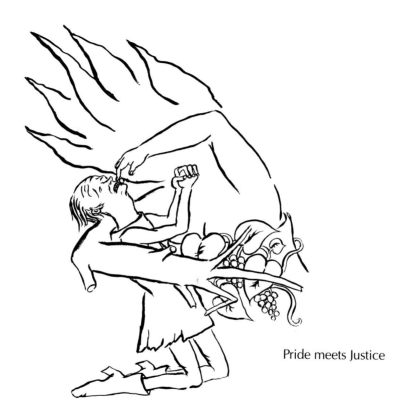

Pride meets Justice

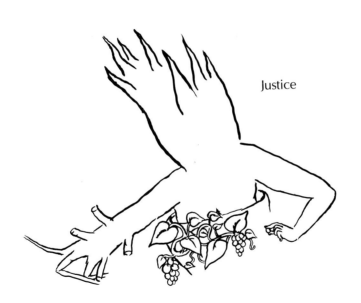

Justice

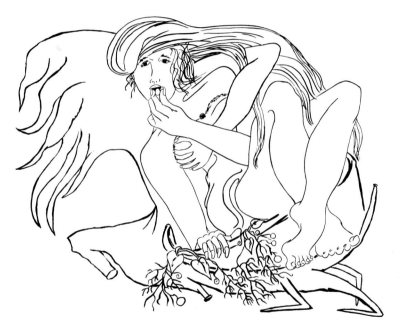

Justice meets Lust

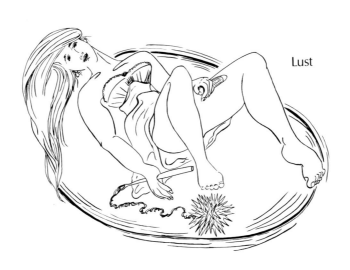

Lust

Lust meets Faith

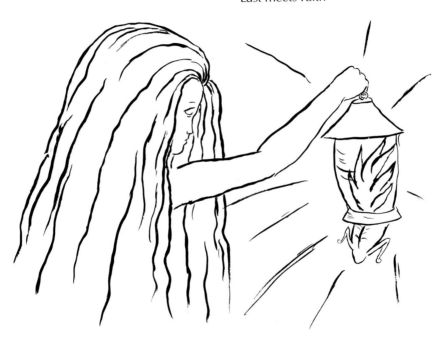

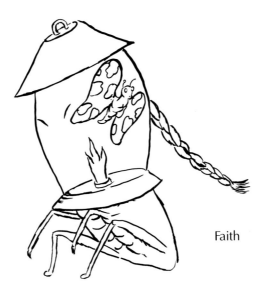

Faith

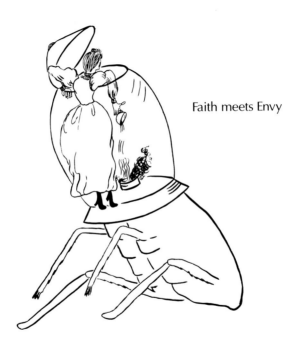

Faith meets Envy

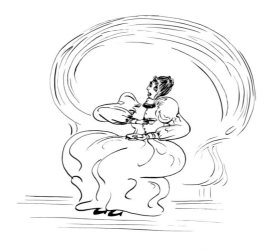

Envy

Sandra Meigs lives in Victoria, British Columbia, where she teaches and pursues her artistic career. Her work has been exhibited throughout North America. Her depiction of vice is direct, theatrical and literal, reflecting her interests in popular culture and in transgressing existing bounds of behaviour.

Cecily Moon lives in Long Island, New York, and Toronto, Ontario. Her work has been exhibited throughout Canada and the United States. In contrast to the images of vice, her representations of virtue are symbolic, allowing for equivocal, shifting and oblique allusions to classical culture.

The approaches of both artists are stylistically opposite to most historical depictions of the virtue-versus-vice theme.